Wallpaper

Zoë Hendon

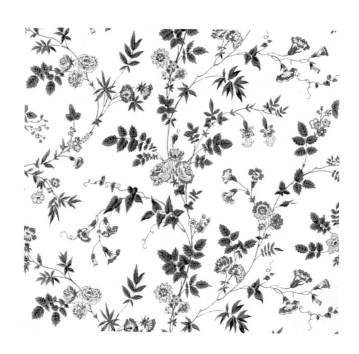

SHIRE PUBLICATIONS

Bloomsbury Publishing Plc
PO Box 883, Oxford, OX1 9PL, UK
1385 Broadway, 5th Floor, New York, NY 10018,
USA

E-mail: shire@bloomsbury.com

www.shirebooks.co.uk

SHIRE is a trademark of Osprey Publishing Ltd

First published in Great Britain in 2018

A catalogue record for this book is available from the
British Library.

ISBN: PB 978 1 78442 313 1
 eBook 978 1 78442 312 4
 ePDF 978 1 78442 311 7
 XML 978 1 78442 315 5

18 19 20 21 22 10 9 8 7 6 5 4 3 2 1

Typeset by PDQ Digital Media Solutions, Bungay, UK

Printed in India by Replika Press Private Ltd

Shire Publications supports the Woodland Trust, the
UK's leading woodland conservation charity. Between
2014 and 2018 our donations are being spent on their
Centenary Woods project in the UK.

COVER IMAGE
William Morris *Pimpernel* wallpaper, 1876 (Getty
Images). Back cover detail: An American frieze by
Maxwell & Co., *c.*1890–1920. (Smithsonian Design
Museum)

TITLE PAGE IMAGE
Mass production meant an increasing need for a
system of copyright, to prevent piracy of design ideas.
The Ornamental Designs Act was passed in 1842, and
this wallpaper design was registered in 1843.

CONTENTS PAGE IMAGE
Sanitary wallpaper could be purchased varnished or
unvarnished, which was cheaper. This example of an
unvarnished sanitary wallpaper frieze features a stylised
floral Art Nouveau pattern, intended to imitate tiles.

ACKNOWLEDGEMENTS
Thank you to all those who have allowed me to use
illustrations, which are acknowledged as follows:

Bridgeman Art Library, pages 6, 12, 15 (top), 27
(top), 29 (top), 44; Brixton Print Shed, page 57;
The Geffrye, Museum of the Home, London, pages
43 (bottom), 52; Graham Sutherland Estate, page
38; Hamilton Weston, page 11 (both); © Historic
England Archive, pages 8 (top left), 10; Mini
Moderns, page 58; Museum of Domestic Design
and Architecture, Middlesex University, pages 3, 5,
15 (bottom), 16 (top), 18, 20 (top), 21 (both), 22,
24, 27 (bottom), 28, 29 (bottom), 30, 32 (both),
33 (both), 34, 35, 36, 41, 42, 46, 47, 49, 50 (both);
The National Archives, pages 1, 14, 20 (bottom), 26;
National Trust Images, pages 8 (bottom), 17; Newton
Paisley, page 59; Norfolk County Council (Cromer
Museum), page 23 (top); Robin and Lucienne
Day Foundation, pages 39, 40; Sanderson (Abaris
Holdings Ltd), pages 23 (bottom), 32 (bottom), 51,
54 (bottom), 55; © TIME INC. (UK) Ltd, page
48; Topfoto, pages 43 (top), 54 (top); Tracy Kendall
Wallpaper, page 56; © Victoria and Albert Museum,
London, pages 8 (top right), 9, 16 (bottom).

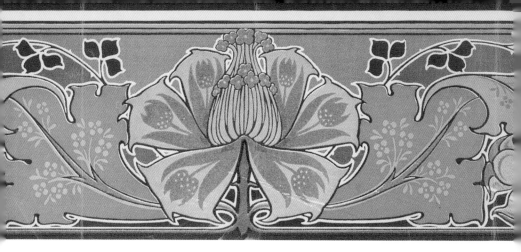

CONTENTS

INTRODUCTION 4

SEVENTEENTH- AND EIGHTEENTH-CENTURY LUXURY 7

NINETEENTH-CENTURY MECHANISATION 13

THE AESTHETIC AND ARTS & CRAFTS MOVEMENTS 19

WALLPAPER IN THE HEALTHY HOME 25

EARLY TWENTIETH-CENTURY WALLPAPERS 31

POST-WAR REVIVAL 37

DOING IT YOURSELF 45

PLACES TO VISIT 60

FURTHER READING 63

INDEX 64

INTRODUCTION

OVER HUNDREDS OF years wallpaper has been used to decorate the most intimate and personal of the spaces we inhabit – the home. The history of wallpaper is the story of changes in fashion and taste, industry and technology, and trade and empire. Thinking about wallpaper is a starting point for thinking about changes in the way we use the spaces in the homes in which we live.

But wallpaper has not always had the attention it deserves. It generally occupies the background rather than the foreground of our lives, but in doing so it can reveal a lot about who we are or who we would like to be. Wallpapers are frequently an expression of personal taste and a way of helping to define personal identity.

Wallpaper has been produced and sold in great quantities in Britain over the past few hundred years. Despite this it is not always easy to find out much about how people actually used it. It is much less permanent than other kinds of furnishings and it does not have the same status as furniture or silverware that can be more easily inherited or collected. Rooms tend to be papered and then re-papered on a regular basis. It is relatively rare to find old photographs or other records that show how wallpaper was used alongside other furnishings. (Even in the twentieth century people did not routinely photograph their own homes.)

When fragments of wallpapers survive in museums they tend to be separated from their context and displayed as

'art'. This book looks at how wallpaper was made and sold and tries to put it back into the context of how it was used in the home. Wallpaper has also been used in commercial and institutional spaces such as hotels and hospitals, but the focus here is on its use within domestic spaces. What do we know about how wallpaper was used in Britain in the past? How was it used to demarcate different kinds of space within the home? This book draws on evidence of wallpaper in museums and stately homes, as well as advertisements and photographs of real domestic interiors.

Geometric wallpaper patterns such as this were fashionable throughout the 1930s. This paper uses an 'autumnal tints' colour scheme of shades of orange, red, brown and green.

The history of wallpaper is intimately connected to histories of trade and empire; the American War of Independence affected trade with North America in the eighteenth century, and rivalries with French manufacturers informed British industrial policies in the nineteenth century. As the British Empire spread around the globe, the export of wallpaper helped Britons living abroad to make a house feel like 'home', even on the other side of the world. Here, though, the focus is on wallpaper in homes within Britain.

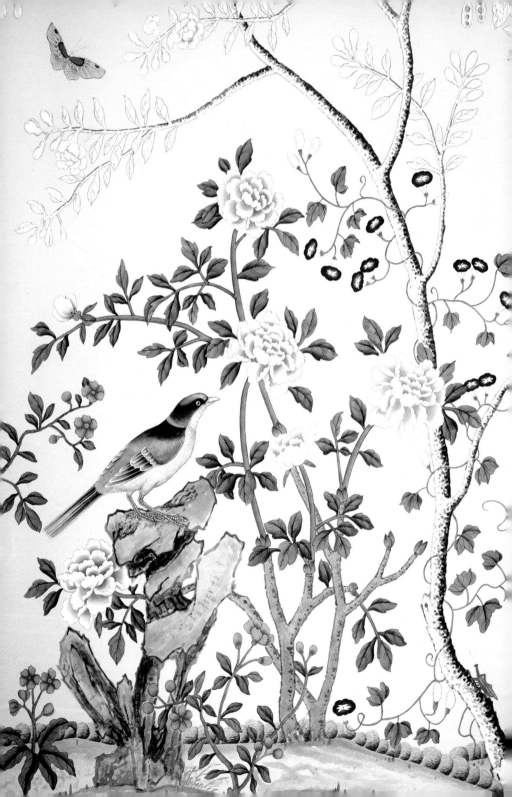

SEVENTEENTH- AND EIGHTEENTH-CENTURY LUXURY

IN THE SIXTEENTH and seventeenth centuries wallpaper was expensive because paper could only be produced in small sheets rather than continuous rolls. Printing techniques were not well developed. One of the oldest known examples of wallpaper is a block-printed paper from a house in Lambeth, London, which dates from the 1690s. The house was in Paradise Row, a street quite close to Lambeth Palace.

Wealthy people frequently used textiles such as woven silks and tapestries to decorate their walls. But this was expensive, and throughout its history, wallpaper has been both celebrated and criticised for its ability to imitate other materials, especially textiles. The Paradise Row wallpaper was probably based on a textile design, and was perhaps a more economical way to achieve that effect than using actual textiles.

Flock wallpaper was another kind of paper intended to imitate textiles. To make flock paper the printer would first print a design onto paper with glue, then sprinkle it with finely chopped wool. The wool would stick to the glued areas only, creating an effect similar to a woven silk or velvet. It was a major innovation from around the 1680s and the technique was further improved by the 1740s. The addition of stencilled colour on parts of the pattern could make a flock wallpaper look more like a damask or velvet, and therefore even more impressive. Many of Britain's stately homes still contain examples of flock wallpapers that were first hung centuries ago.

OPPOSITE
Hand-painted Chinoiserie wallpaper from Marble Hill House in Twickenham, chosen by Henrietta Howard.

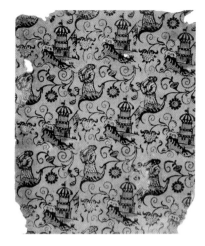

RIGHT
This wallpaper from Paradise Row in Lambeth dates from around 1690. The design features oriental figures and exotic buildings in blue on a buff ground.

FAR RIGHT
This luxurious flock wallpaper was used in the 1830s to decorate the ballroom of Lydiard House in Wiltshire. A wallpaper of the same pattern was used at Temple Newsam house near Leeds in the 1720s, showing the longevity of such styles.

The owners of Christchurch Mansion in Ipswich chose a magnificent red flock wallpaper to decorate the State Bedroom in the 1730s or '40s. Another example of flock wallpaper can be found at Ormesby Hall in Cleveland, now owned by the National Trust. Flock wallpapers like these have frequently survived *in situ* because they were high-quality, luxury products, and were installed in houses that have been preserved over the generations.

In the eighteenth century Chinese wallpapers were popular with some of Britain's wealthiest people. Chinese wallpapers were first imported by the East India Company in the late 1600s. By the early 1700s, they were frequently paired with other imported products such as Chinese porcelain and lacquer ware to create a whole

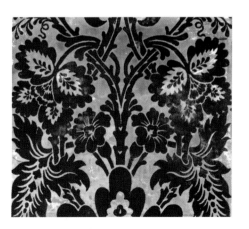

Flock wallpaper was used to decorate the dressing room of Ormesby Hall in Middlesbrough. The Georgian mansion was the home of the Pennyman family in the eighteenth century.

decorative scheme. Initially the fashion was for painted silks that were hung on battens on the walls. These were gradually replaced by painted or printed papers, which were often large scale and scenic. As Emile De Bruijn points out in *Chinese Wallpaper in Britain and Ireland*, many of these Chinese wallpapers have survived and can still be seen in Britain's historic houses, from Newhailes House in Scotland, to Saltram House in Devon, and many places in between.

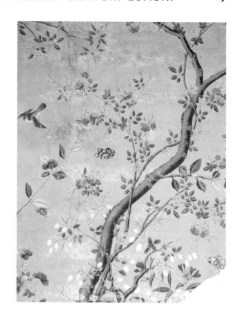

Chinese wall hangings frequently featured landscape scenes rather than repeating patterns. Some elements were printed, with detail added by hand. Because of this they occupy a kind of half-way point between paintings and wallpaper. Chinese wallpapers were extremely expensive because they were hand-made by skilled artisans and imported from the other side of the world. Choosing a wallpaper of this kind was a statement of fashionable taste as well as wealth. Henrietta Howard, of Marble Hill House in Richmond, installed a magnificent hand-painted Chinese wallpaper in 1750. This cost £42 and 2 shillings, representing a huge expense. We can get an idea of just how expensive it was by comparison to the annual salary for the household's cook, which was only £8 per year.

This sample of Chinese wallpaper with flowering shrubs, birds and insects on a pale green background is now in the Victoria & Albert Museum, but similar examples can be seen in historic houses around Britain.

Block printing was the method most commonly used to print wallpapers in Britain in the eighteenth century. Wallpaper printers, or 'paper stainers', as they were known, used carved wooden blocks, first dipping them into pigment then pressing onto paper. The blocks generally measured around 24 by 32 inches, and weighed 30–40lb (around 15kg), meaning that printers required considerable strength and stamina as well as skill. The techniques were similar to those

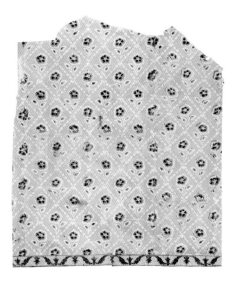

used to print patterns onto fabrics. Wallpaper making required significant investment of equipment and space to dry the papers after they were printed. Between around 1690 and 1840 the British wallpaper industry was located mainly in London, though there is some evidence for local production in other provincial cities and in Ireland. The eighteenth century was a time of rapid urbanisation: London was home to around 10 per cent of the population of England and Wales by the late 1700s. Other cities such as Bath, Birmingham, Liverpool and

This block-printed and stencilled paper is from Whitehall House, Cheam in Surrey. It dates from around 1741, when the tenancy of the house was taken by the Killick family.

York, were expanding too. Wallpaper was becoming more affordable, though it was still regarded as a 'luxury trade'. Tax was payable on wallpaper between 1712 and 1836. But house builders favoured wallpapers because they were cheaper and easier to install than wainscoting (wood panelling), and consumers appreciated wallpaper for the sense of affordable luxury it offered.

By the early 1800s wallpaper had become a standard requirement for the furnishing of any respectable middle-class home. Amanda Vickery points out in *Behind Closed Doors* that as wallpaper came within the reach of the slightly less well off it became accompanied by anxiety about social status. Wallpaper was becoming a battleground for debates over the appropriate display of wealth. Choosing wallpaper to decorate one's home meant saying something about the social class you thought you were, or aspired to be. Paper stainers tried to produce papers to suit every pocket by re-using printing blocks in different combinations to create different patterns, and by employing cheaper unskilled labour to do some of the more menial tasks.

Original examples of block-printed wallpaper from the eighteenth and early nineteenth centuries are relatively rare. They were generally used to decorate houses that have seen frequent changes of owner, and have therefore been removed or replaced many times. But recently several examples of early block-printed papers have been discovered in historic houses and recreated using traditional printing methods. This enables us to get a much better idea of how wallpaper would have looked and how it would have been used in those spaces. Wallpaper specialists Hamilton Weston have reprinted wallpapers for Jane Austen's house in Hampshire and for the home of J.M.W. Turner in Twickenham. Both examples are of small block-printed patterns dating from the early 1800s. The original papers would have been economical to print, and are representative of middle-class taste for wallpapers that were 'neat' but not too 'showy'.

Chawton Vine, a modern reproduction of a block-printed wallpaper dating from 1805, from Jane Austen's house, Chawton in Hampshire.

Sandycombe Lodge, named after the home of the artist J.M.W. Turner in Twickenham. The original wallpaper dated from around 1813. This modern reproduction was printed using traditional block-printing methods.

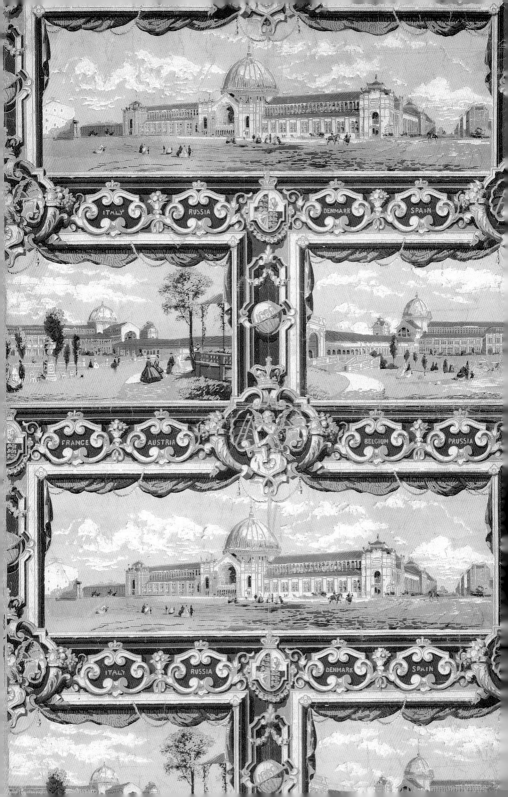

ITALY RUSSIA DENMARK SPAIN

FRANCE AUSTRIA BELGIUM PRUSSIA

ITALY RUSSIA DENMARK SPAIN

NINETEENTH-CENTURY MECHANISATION

IN THE EARLY 1800s several new inventions began to make the production of wallpaper cheaper and more rapid than ever before. In 1785 Christophe-Philippe Oberkampf invented a machine for printing wallpaper using engraved copper rollers, and in the early 1800s the Fourdrinier brothers patented a machine for producing paper in continuous rolls rather than in single sheets. These new technologies were not adopted instantly, since they required considerable financial investment, but over the first few decades of the nineteenth century more mechanised processes were introduced into wallpaper factories. Machines could now produce hundreds of yards of wallpaper per day using lower skilled labour. This was in contrast to the block-printing method, which required skilled workers and resulted in only few yards of finished paper per day.

In 1834 Britain was producing around 1.2 million rolls of wallpaper per year; this rose to 5.5 million by 1851 and as much as 32 million by 1874. As a result, wallpaper became much more affordable, moving from a luxury product to an everyday commodity. Machine printing resulted in wallpapers that could look quite different from the older block-printed papers. The use of engraved rollers rather than carved wooden blocks made it possible to achieve finer detail and greater effects of shading and perspective.

It is relatively difficult to find early nineteenth-century examples of machine-printed papers *in situ* now. This is

OPPOSITE
Wallpapers that featured scenic views and multiple perspectives were popular in the nineteenth century. This wallpaper commemorates the International Exhibition of 1862, held in South Kensington to celebrate Britain's contribution to industry, technology and the arts.

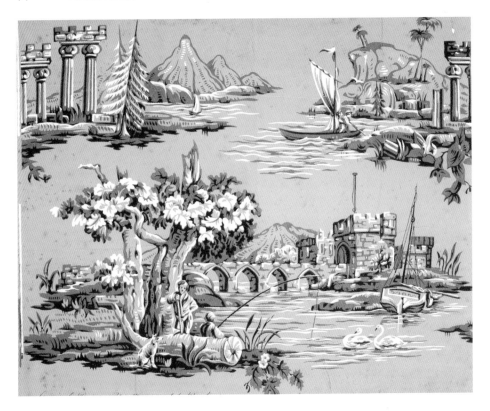

This design for a paper hanging dates from 1844 and includes rural scenes as well as classical ruins. It uses only three colours so may have been quite economical to print.

because their cheapness meant they were easily replaceable and their low status meant that they were rarely donated to museum collections. Often the less expensive designs did not look significantly different from the more expensive ones, but were cheaper because they were printed on poorer quality, thinner papers. We know about the kind of wallpapers that were popular because some were registered at the Public Record Office. We also have evidence from paintings of domestic interiors, in which wallpaper was often depicted as a background to solid respectability.

By the mid-nineteenth century, wallpaper had become a necessary part of the furnishing of any home, for both rich and poor. Consumers paid great attention to where they hung their wallpapers. The more expensive and showy papers were

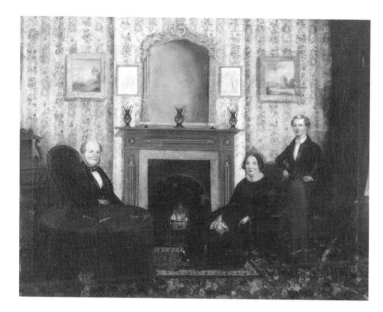

Portrait of a middle-class family in their home in Hull, 1852. The room's floral wallpaper suggests the family's solid social status, being suitably fashionable but not too showy.

generally seen as appropriate for public rooms, and cheaper, plainer papers used for bedrooms and servants' quarters. Middle-class consumers favoured wallpapers with large naturalistic floral designs, adding to the impression of the gloomy and overstuffed Victorian interior. Wallpapers that imitated other materials, such as bricks, wood, granite and marble, were also popular.

However, many Victorian design critics disliked the profusion of cheaper wallpapers. They believed that the quality of wallpaper design had declined as it had become more affordable. Design reformers had strong views

This wallpaper is machine-printed with a design that imitates marble and granite, and was probably intended for use in a hall. Victorian consumers appreciated wallpaper's ability to imitate the appearance of other materials.

This design features large yellow roses and green leaves, on a pink ground. It is typical of the middle-class taste in the 1880s for large, demonstrative wallpaper patterns.

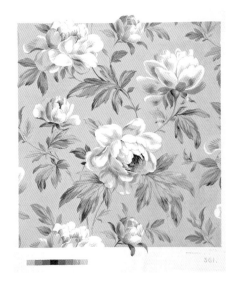

about the kinds of pattern that were appropriate for walls. They argued that wallpaper should feature patterns that were clearly flat, rather than attempting to depict three-dimensional floral bouquets or scenic landscapes.

One designer who responded to this was Owen Jones, author of the influential book *A Grammar of Ornament* (1856). Jones' designs for wallpapers were influenced by Islamic art, a tradition that completely rejected naturalism.

This block-printed wallpaper with a formalised floral design, by Owen Jones, dates from between 1852 and 1874.

He sought to develop a modern style that was not associated with nineteenth-century historical revivals such as the Gothic and neo-classical. His wallpapers show his interest in simplified and formalised motifs that do not attempt to imitate three-dimensional forms. Jones was what we would now think of as an industrial designer, working in a variety of media for a number of different manufacturers.

Another designer who criticised the design of cheaper wallpapers was Augustus Welby Northmore Pugin, the architect of the Houses of Parliament. The rebuilding of Parliament offered Pugin the opportunity to design a space, and several wallpapers, that used gothic motifs such as the fleur-de-lis, crowns and coronets. Pugin's wallpaper was widely used in castles and stately homes, and he also designed several for his own home in Ramsgate. His wallpapers were block printed by hand, making them an expensive statement of luxury.

Lanhydrock in Cornwall was home of the second Lord Robartes. A major fire meant that the house was largely rebuilt in the 1880s, in full late-Victorian style. The wallpaper in Robartes' bedroom is a copy of a Pugin design for the Robing Room of the House of Lords.

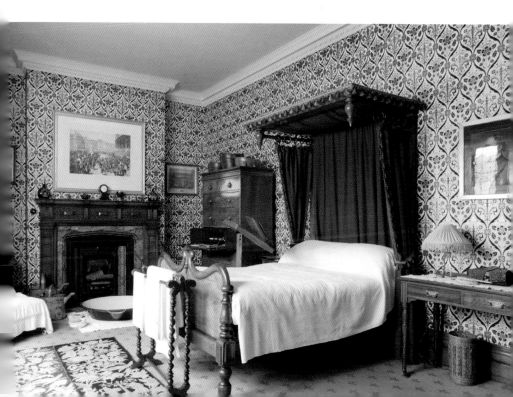

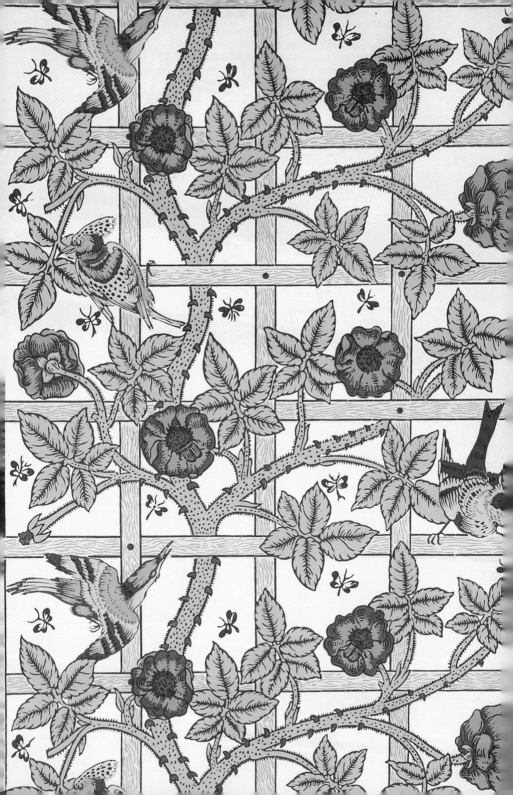

THE AESTHETIC AND
ARTS & CRAFTS MOVEMENTS

B Y THE 1860s and '70s there was so much more wallpaper on offer that consumers needed advice on how to navigate through all the choices available. Good design was believed to contribute to a happy and healthy home. A number of advice manuals were published which aimed to help consumers to make the right choices in domestic furnishings. Mrs Panton, author of several books of domestic advice, suggested that her readers should visit the department store William Wallace and Co. Other shops, such as Liberty and Whiteleys in London, and department stores in other major cities, published illustrated catalogues to help guide consumers.

By the 1880s it was common to divide the wall into three horizontal bands, as recommended by Charles Eastlake in *Hints on Household Taste* (1868). The lowest part of the wall was called the dado; the middle section (between chair rail and picture rail) was the filling; and the upper part was the frieze. The filling was generally the plainest part as it formed a backdrop to pictures hung on the wall, but the idea was that all three papers should be complementary in colour and style. The *Punch* cartoonist Linley Sambourne adopted this fashionable style of decorating at his house in London in 1875.

Among the wallpaper designers frequently recommended to the fashionable middle classes was William Morris. We now think of William Morris as the foremost British wallpaper designer of the nineteenth century, but when he started his business in 1861 it specialised in furniture, tapestries and

OPPOSITE
Trellis wallpaper, 1862. This was the first wallpaper that William Morris designed although it was the third to be issued. It was inspired by the garden of Morris's home, Red House, in Kent.

The drawing room illustrated in the William Wallace & Co. catalogue of 1895 has many fashionable Victorian features. There is an ornate overmantel above the fireplace and the walls are decorated using three patterned, complementary wallpapers.

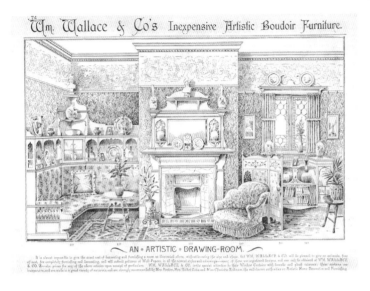

Wm. Wallace & Co's Inexpensive Artistic Boudoir Furniture.

AN ● ARTISTIC ● DRAWING ● ROOM.

stained glass. He designed his first wallpapers in 1862, and from 1864 commissioned the established wallpaper firm Jeffrey & Co. to print his designs for him. Morris had strong opinions about the kinds of pattern that were appropriate for wallpapers, believing that plants and flowers should give the impression of growing naturally up the wall.

Morris and some of his contemporaries argued that block printing was a more 'honest' way of producing wallpaper than machine printing. This was partly to do with the appearance of

These two designs for wallpaper from 1886 show the fashion for dividing the wall into three horizontal bands – 'dado', 'filling' and 'frieze' – interspersed with matching borders in shades of olive green and gold.

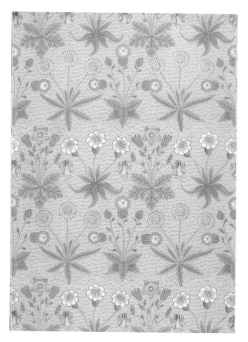
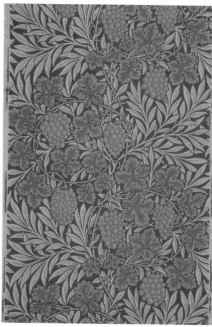

the designs – the nature of block printing meant that designs tended to appear flatter rather than attempting to achieve perspective effects. But Morris also preferred block printing because of his ideas about the honesty of craft production. He opposed the dehumanising effects of factory work and favoured the supposedly better working conditions of the skilled craftsman. However, as Morris's biographer, Fiona MacCarthy has pointed out, printing wallpaper by hand remained a repetitive and uncreative endeavour.

Wealthy clients could commission Morris & Co. to design a whole interior scheme for their home, as the Beale family did at Standen in West Sussex. Morris & Co. was among the first companies to offer a fully designed interior, including wallpaper, rugs, embroideries and furniture and so on, all unified in terms of colour and style. The 'Morris look' included rich colours, inspiration from nature and flowing lines. Alternatively, customers could simply order the items they

ABOVE LEFT
William Morris
Daisy wallpaper,
1864, printed by
London wallpaper
firm Jeffrey & Co.
for Morris & Co.

ABOVE RIGHT
Vine wallpaper,
William Morris,
1873. The
Mander family, of
Wightwick Manor,
were inspired by
Oscar Wilde's
idea of 'the
House Beautiful'
and chose
Morris & Co.
papers.

Walter Crane,
Sleeping Beauty,
designed in 1875
and registered
by Jeffrey & Co.
in 1879. As an
illustrator of
children's books,
Walter Crane
returned to the
theme of the
Sleeping Beauty
throughout his
career.

required from the Morris & Co. shop or catalogue. Wightwick Manor near Wolverhampton was built in 1887 for industrialist Samuel Theodore Mander and his family. The Mander family chose wallpapers by Morris & Co. as a backdrop for their collections of Arts & Crafts furnishings and Pre-Raphaelite paintings.

Following Morris's lead, firms such as Jeffrey & Co. began to commission named artists to design wallpaper for them. One of the designers employed by Jeffrey & Co. was Walter Crane, an artist also known for his work as an illustrator of children's books. Crane's wallpapers frequently feature rich colours and luxuriant foliage, and include figures from popular fairy tales. By the end of the nineteenth century, the style now known as Art Nouveau had become fashionable. Wallpapers featuring rich swirling patterns were often paired with an eclectic mix of furniture, prints and ornaments.

William Morris wallpapers remained popular in the twentieth century and are still reproduced today. So it is easy to forget that only a small proportion of consumers chose them to decorate their homes in the 1880s and '90s. The Morris style of wallpaper was fashionable, but not everyone could afford expensive hand-printed papers. Other wallpaper companies offered designs that looked similar but which were more affordable. The residents of a house in Cromer in the 1890s chose wallpaper that looked similar to a Morris design, but was in fact produced by Sanderson in around 1885. It was surface roller printed by machine, rather than block printed, and sold for 9 pence a yard. The design was called *The Rossetti*,

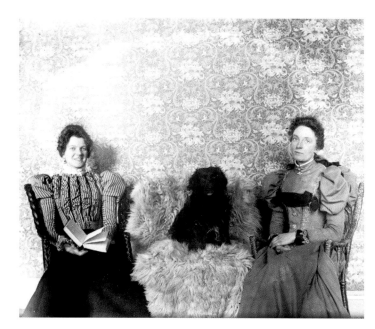

Interior photograph, early 1890s, by Daniel Davison of Cromer, showing *The Rosetti* wallpaper produced by Sanderson in 1885. The younger woman on the left is probably Davison's wife.

a title that linked the wallpaper to the artist Dante Gabriel Rossetti, a member of Morris's circle, and thus suggests something of the aspirational nature of the design.

The names of the majority of nineteenth-century wallpaper designers are not known to us now. Designers who worked for firms such as Sanderson were not credited personally. New designs were often based on older patterns or sources such as textiles. William Morris was one of the first people to understand the value of attaching an individual name to a product, and of marketing his wallpapers as 'art', ensuring that they maintained an exclusive appeal for his wealthy clients.

The Rossetti wallpaper was available in a variety of different colourways, with an accompanying border. The border was re-issued by Sanderson in 1978 under the name 'Country Garden'.

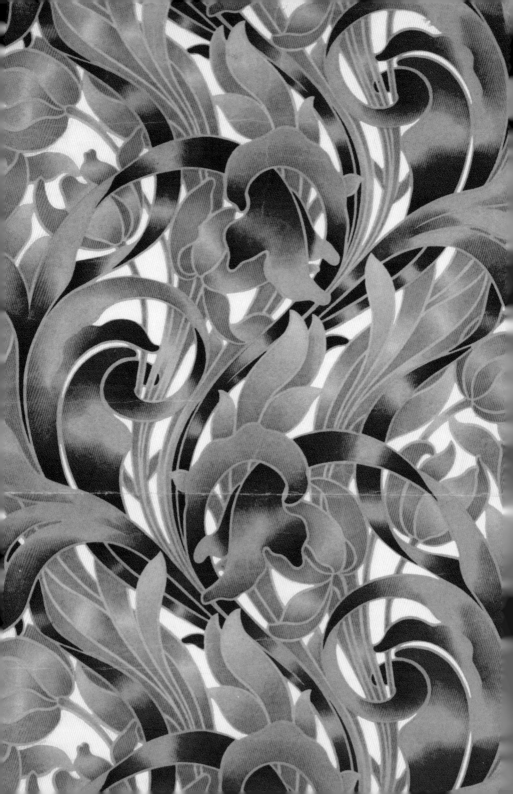

WALLPAPER IN THE
HEALTHY HOME

IN THE NINETEENTH century, choice of wallpaper was frequently a battleground for debates around health and hygiene in the home. Sometimes these debates expressed concern for physical health and sometimes the emphasis was on spiritual or moral health.

By the early 1800s, new advances in scientific understanding of chemistry meant that it was becoming possible to produce wallpaper with brighter, more vivid colours. One of these new chemicals was white arsenic, known as 'Scheele's Green', first identified by a Swedish chemist, in 1775. This combined with new wallpaper printing techniques led to a fashion for bright vivid colours. Arsenic is mainly associated with the colour green, but in fact it could be used in other colours to improve their vividness and durability.

As Lucinda Hawksley has pointed out in *Bitten by Witch Fever*, arsenic was well known as a domestic poison in the early 1800s. It might therefore have seemed obvious that arsenic in wallpaper would be harmful to health. However, it took a long time for the dangers of arsenic in wallpaper to be recognised. From the 1850s, doctors started to raise concerns in the medical press about arsenic poisoning resulting from wallpaper. But it was difficult to prove, since the effect of arsenic depended on other factors such as the humidity in a room. Arsenic also seemed to affect different people to differing degrees; a number of people might share the same room but not all of them would fall ill.

OPPOSITE
Flaming Tulips,
Arthur Gwatkin,
1903. This
Art Nouveau
sanitary
wallpaper
is typical of
the work of
the Glasgow
company, Wylie
& Lochhead, then
one of Britain's
largest furnishing
and decorating
firms.

This wallpaper was designed by Christopher Dresser in 1860. Recent research has shown it to be 'highly likely' that it contained dangerous levels of arsenic pigments.

Another problem was that it was wrongly understood by the public that only green pigments contained arsenic and were therefore harmful. From the 1870s some wallpaper companies including Jeffrey & Co. made a point of marketing their products as 'guaranteed arsenic free', in response to public concern. The British surgeon and health campaigner, Thomas Pridgin Teale, published a book called *Dangers to Health: A Pictorial Guide to Domestic Sanitary Defects*, in 1883. In it he noted:

About seven years ago my own children were unwell from sleeping in a newly papered bedroom. The paper had a brilliant green pattern and was guaranteed 'free from arsenic'. The illness of one child after another led me to have the paper examined by my friend Mr Scattergood and he reported the paper full of arsenic in a loose and dangerous form. The paperhanger was dismayed, replaced the paper, and, I believe, no longer takes 'warranted' paper on trust…

William Morris himself remained unconvinced that arsenic in wallpaper might be dangerous to health, claiming that medical professionals had been wrongly persuaded by the evidence, or 'bitten by witch fever'. Several of Morris's early wallpapers are now known to have originally been printed with arsenic pigments, including *Daisy*, *Fruit*, *Trellis*, *Venetian*, *Scroll* and *Larkspur*.

The use of arsenic in printing had made it clear to the public that the choice of wallpaper in the home could have an effect on the health or otherwise of the household.

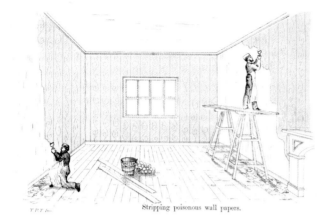

Stripping poisonous wall papers.

'Stripping poisonous wall papers'. An illustration from Thomas Pridgin Teale's *Dangers to Health: A Pictorial Guide to Domestic Sanitary Defects*, first published in 1883.

An innovation from the early 1870s was the invention of a new kind of wallpaper printing. The Manchester firm of Heywood, Higginbottom & Smith developed washable paper printed in oil colour using copper rollers. The rollers were very finely engraved, and the use of oil-based rather than water-based inks produced papers that were washable – or at least wipeable. These became known as 'sanitary' papers.

The 'sanitary' printing process made it possible to print wallpapers featuring shaded effects, because the colour was transferred to the paper in the form of tiny dots. Using this technique it became possible to create realistic pictorial designs very cheaply. The cheapness and the hygienic qualities of sanitary wallpapers mean that they became widely used in working-class homes. They were also popular in middle-class homes for hallways and for children's rooms where papers got harder wear.

As in earlier centuries, wallpaper was still prized for its ability to imitate other materials. Wallpaper could be made to look like expensive wall coverings such

A sanitary wallpaper from around 1905 featuring a pattern of large pink peonies with green leaves. The influence of Art Nouveau can be seen in the curving lines of the design.

This sanitary print nursery wallpaper of 1895 was based on Kate Greenaway's illustrations of popular nursery rhymes, making it a good choice for a child's room.

as marble, wood panelling and tiles, and many regarded wallpaper as superior to these 'real' materials in terms of durability as well as cost.

Several other new kinds of wallpapers were developed in the 1870s and '80s, which were marketed for their hygienic properties. Lincrusta (first known as Lincrusta-Walton) was developed by Frederick Walton, who was also the inventor of linoleum. Lincrusta wallpaper was made of a mixture of oxidised linseed oil mixed with gum, resin and filler made of wood pulp and paraffin wax. The mixture was fed through rollers, one of which was moulded to create an embossed pattern, then backed on to waterproof backing paper. This resulted in textured wallpaper that could be made to imitate plaster, wood panelling or embossed leathers. It became a popular choice for public buildings as well as domestic interiors because it did not absorb moisture, was easy to clean and was therefore hygienic. Lincrusta-Walton was awarded a Gold Medal at the 1884 International Health Exposition in London.

The main rival to Lincrusta was a new product called Anaglypta, developed in 1883 by Thomas Palmer. Anaglypta was made from paper or cotton pulp, which meant it was possible to make embossed patterns with much deeper reliefs. It was best suited to be an imitation of plaster, and since it was lighter than Lincrusta it was particularly suitable for ceilings. It was similar to Lincrusta in that it could be sized and painted, making it waterproof and therefore hygienic, but it was also cheaper. By 1893, Anaglypta was one of the most important wallcoverings on the market.

Other rival brands of embossed wallpaper were available, including one known as Tynecastle paper. This

was used extensively by Merton and Annie Russell-Cotes in the decoration of their house in Bournemouth (now the Russell-Cotes Art Gallery and Museum). Like Lincrusta, Tynecastle paper was richly embossed and could be painted or embellished. Tynecastle papers created a luxurious backdrop to the Russell-Cotes' collection of paintings and curios that they had collected on their extensive travels.

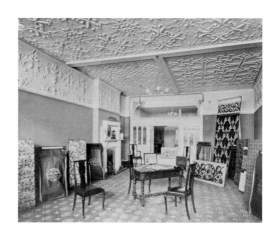

Frederick Walton's Lincrusta showroom, London, in the early twentieth century, showing the wide choice of embossed and textured wallpapers that were available.

Embossed papers such as Lincrusta and Anaglypta continued to be sold well into the twentieth century. They were hardwearing and could be painted over numerous times. But their durability could also be a problem: many people still remember these kinds of papers for the difficulty they presented when attempting to remove them from the wall.

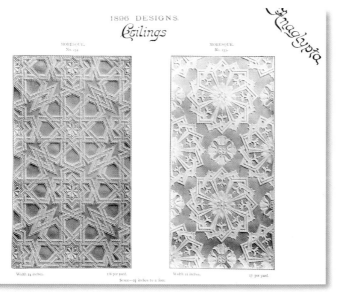

1896 DESIGNS.

Ceilings

MORESQUE. No. 174.

MORESQUE. No. 175.

Anaglypta

Width 24 inches. 1/6 per yard.

Width 22 inches. 2/- per yard.

SCALE—2¼ inches to a foot.

This page from the Anaglypta catalogue of 1896 shows some of the company's designs for ceiling decorations, intended to imitate plaster.

EARLY TWENTIETH-CENTURY WALLPAPERS

T HE NUMBER OF rolls of wallpaper produced in Britain grew steadily during the Victorian period. By the 1930s output had increased to around a hundred million rolls per year. The majority of those millions of rolls were cheaper papers for which surprisingly little evidence survives. Wallpapers have been removed or papered over countless times in the past century. Fashions have changed and new inhabitants have used wallpapers to make a house feel like their own.

A photograph of a young man in the front parlour of a middle-class home in Leamington offers a rare glimpse into the decorative choices of an ordinary family. From his clothes and his studious pose we can guess that this young man might be a clerk – perhaps the photograph was taken to record his first day at work? The wallpaper in this photograph was produced by Arthur Sanderson and Son in 1910–11, and is an up-to-date feature of the room. It contrasts with some of the other furnishings, such as the chaise longue and the pictures, which are older. Wallpaper was often used as an inexpensive way to update or freshen up a room since it was cheaper to replace than items of furniture, which were expected to last a lifetime.

In the 1920s and '30s, wallpaper came to be regarded as rather unfashionable by the design elites. They preferred plain distempered walls, with touches of colour added to the room by means of cushions and curtains. Writing in the

OPPOSITE
This illustration taken from a wallpaper catalogue by T. Whatley & Son of Middlesbrough, 1937, shows how the cut-out corner borders applied over plainer wallpaper were intended to look.

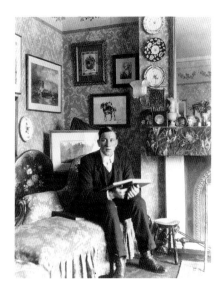

The wallpaper in this house in Leamington dates the image to around 1910–11.

Architectural Review in February 1932, the architect F.R.S. Yorke commented:

Wallpaper, that old exponent of disgusting designs, has declined in popularity and become a standing joke merely because the manufacturers lack the initiative to introduce patterns which, because they stray a little from the accepted flowery groove, may be a slight commercial risk.

Yorke's comments highlight the ongoing challenge for wallpaper manufacturers: how to produce wallpapers that would be novel enough not to look old fashioned, but traditional enough to appeal to consumers. Modernist architects like Yorke may have disliked wallpaper, but the public continued to buy it in huge quantities, seeing it a necessary component of a respectable home.

This blue and white wallpaper by Arthur Sanderson & Sons Ltd is the one seen in the photograph above. This paper is typical of the first decade of the twentieth century, but is based on an eighteenth-century design.

In the 1920s, there was a fashion for plain wallpapers with cut-out friezes overlaid on top. These featured motifs such as birds and flowers that might trail from the upper part of the wall, or appear to 'grow' from below. Sometimes sections of frieze might be used in different combinations to create different effects. Though they were machine printed on cheap

FAR LEFT
A machine-printed wallpaper from 1926 featuring a frieze of hanging blossoms and birds. The plain background wallpaper was two shillings and sixpence per piece, with the border an additional shilling per yard.

LEFT
This elaborate cut-out wallpaper border features *The Rock Garden*, a design intended for the lower edge of the wall. Extra pieces with *Wistaria Tree* (shown here) or *Rhododendron* motifs could be applied above it. This paper was produced by John Line & Sons in 1928.

papers, some of these designs were reminiscent of the Chinese wallpapers of the eighteenth century.

In the 1930s, cities such as London began to expand outwards as speculative builders developed new suburbs served by an expanding public transport network. Until this point, the majority of people, rich and poor, had rented their homes, but in the 1930s cheaper mortgages meant that home ownership became an achievable aspiration even for those on relatively modest incomes. As in earlier centuries, house builders frequently included the cost of wallpapering in the overall price of a new house. Wallpapers aimed at this suburban market frequently featured Art Deco motifs such as zigzags and geometric shapes. Modern or Art Deco designs were often given wider appeal by the inclusion of floral motifs.

As wallpaper became cheaper, so manufacturers developed new innovations to make it appear more expensive, and thus

retain its appeal as a luxury product. One way of doing this was to suggest a return to the idea of different wallpapers for the lower and upper parts of the wall. A wallpaper catalogue produced by T. Whatley and Son in 1937, offered its customers:

> Sheer delight in wallpaper decoration – where originality of motif comes without a hint of freakishness. The decorative beauty of the Cactus Design is an inspiration – and an innovation as well! No small part of its distinction lies in the use of the companion papers and the border to build up alternative schemes.

The idea of using several 'companion papers' and borders was a way in which a mass-produced product could be customised to the tastes of individual consumers, but doing so obviously added more expense. Deborah Sugg Ryan has argued that the inhabitants of suburbs in London and elsewhere in the interwar period negotiated their own version of 'modernity', choosing from the wide range of new technologies and styles that were on offer. Their choices may

This geometric border overlaid on a plain ground was probably the sort of thing Mr Freedman of Southgate would have liked for his new home in 1934.

This wallpaper from 1934 combines a traditional floral motif with a more 'modern' geometric background, suggesting that consumers were looking for something 'new' and yet simultaneously familiar.

sometimes have seemed conservative but they were forced to reconcile what they would really have liked with what they could actually afford.

One example is Mr Freedman, an engineer from South London, who bought a new home in Southgate in 1934. As was common at the time, the builder included the cost of papering rooms in the overall purchase price, and offered the purchaser a choice from a limited selection of papers. Surviving correspondence suggests that Mr Freedman initially wanted something better than the standard selection for his two downstairs reception rooms. The wallpaper that he liked was relatively inexpensive at two shillings and sixpence per piece, but he also wanted fashionable fancy borders. These were not costly in themselves but they made the job expensive because of the labour involved in applying them. The building contractor informed Mr Freedman that adding borders would cost an extra 27 shillings and sixpence per room. After some further correspondence, Mr Freedman reluctantly concluded that this was beyond his means, and he settled for the plain wallpapers without the fancy borders.

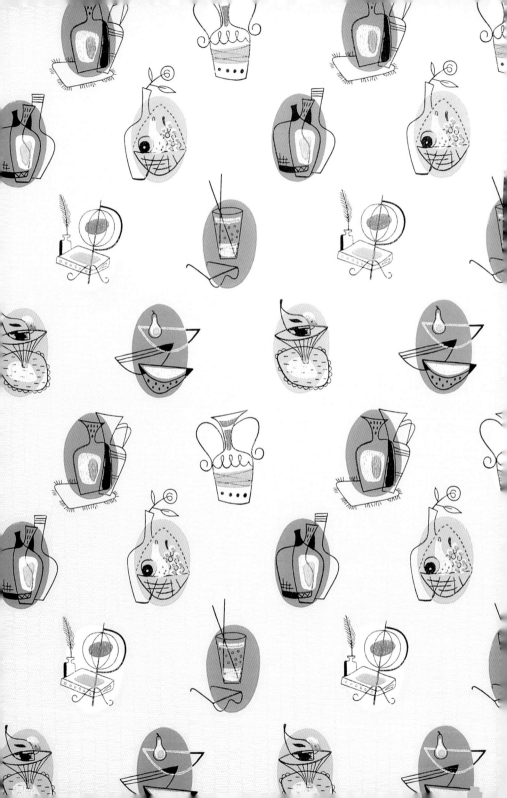

POST-WAR REVIVAL

IN THE YEARS after the Second World War, wallpaper became the focus of effort to revitalise the economy and give a much-needed boost to Britain's depleted housing stock. Manufacturers employed new young designers such as Lucienne Day and June Lyon to create their ranges, and wallpaper became a key part of 'contemporary' post-war style.

The damage to Britain's towns and cities caused by the Second World War left thousands of people homeless. As a result, the building of new houses was at the forefront of the newly elected Labour government's agenda in 1945. Two and a half million homes were built between 1945 and 1957. Many older houses were also in need of renovation, whether as a result of bomb damage or years of wear and tear. People moving into these new homes were presented with a blank canvas that they could decorate to their own tastes.

In the post-war period, wallpaper became associated with ideas of regeneration, not just of individual homes, but of the country as a whole. It was seen as part of the spirit of rebuilding in the post-war economy. The purchase of wallpaper also had very real economic benefits: the government was eager to regenerate all aspects of the British economy and recognised the importance of promoting British design and industry. Home furnishings provided an ideal way to encourage the manufacture and consumption of British products. Domestic furnishings represented the politicisation of the personal, and vice-versa.

OPPOSITE
A 1956 wallpaper featuring household objects such as jugs and fruit (see also page 43). Bright, cheerful colours such as these were popular at this time, in contrast to the autumnal colours of the 1930s.

Abstract by
Graham
Sutherland
was featured
on the cover
of *Architectural
Review* in July
1945, and
was shown at
the 'Britain
Can Make It'
exhibition (1946)
and at the
Festival of Britain
(1951).

The government set up the Council of Industrial Design
(COID) in 1944. It aimed to stimulate the regeneration of
British industry, boost export trade and to increase the home
market. Central to this was the promotion of 'good design' in
all areas of British industry, including the wallpaper and textile
industries. Paper rationing remained in place for several years
after 1945, but despite this the COID encouraged the wallpaper
industry to explore new designs and production techniques.

In the years immediately following the end of the war, the
COID staged a number of exhibitions as a way of promoting
British industry and its principles of 'good design'. The
Exhibition of Historical and British Wallpapers was held in
London in May 1945, featuring wallpapers by more than one
hundred artists and designers, including Graham Sutherland,

Laurence Scarfe, Enid Marx and Marian Mahler. The critics praised the exhibition, but it had a limited impact on the industry and the public as a whole. Only Graham Sutherland's *Abstract*, manufactured by Cole & Sons, achieved any commercial success.

By 1951 the war had been over for six years but rationing and austerity remained part of daily life for the majority of British people. The Festival of Britain was intended to mark the end of this period of recovery. The organisers of the Festival of Britain hoped to promote art and design as a way of boosting morale and building a new post-war society. They aimed to rejuvenate British industry, including the wallpaper industry, by encouraging consumerism at home and abroad, while simultaneously restoring 'British spirit'. Between May and September 1951, over eight and a half million people visited the Festival at the South Bank in London, with countless more taking part in celebrations across Britain.

Provence by Lucienne Day, 1951. A roll of this wallpaper would have cost about 45 shillings, making it an aspirational option for British consumers when the average salary was about £40 a month.

C-Stripe by Lucienne Day, 1954. This was one of several by Lucienne Day that featured in a series of pattern books called The Architects' Book of One Hundred Wallpapers.

The Homes and Gardens Pavilion at the Festival featured a 'low-cost' open plan living/dining room designed by architect Robin Day. It featured modular storage and a built-in radio and television. The room set also featured wallpaper called *Provence* designed by Lucienne Day and produced by John Line & Sons as part of a range brought out to coincide with the Festival. *Provence* featured abstracted plants and geometric shapes in stylish yet muted colours. It offered a visual contrast to pre-war designs and helped to suggest the possibility of a new kind of post-war living.

The post-war period saw an effort to move away from what some saw as the 'boring' and 'traditional' wallpaper patterns of the pre-war era. Two changes to the wallpaper industry helped to make this happen. Firstly, in the 1950s, manufacturers started to recognise the value of employing named designers and selling products under those designers' names. The

Gyro by June Lyon, 1955. The manufacturer John Line & Sons frequently employed freelance designers and was one of the first to give designers a name credit on their work in the 1950s.

wallpaper manufacturer John Line & Sons published its *Limited Editions* range in 1951. It was a self-consciously adventurous collection which featured wallpapers designed by Lucienne Day, Jacqueline Groag and others. Bold, spiky patterns with an abstract, hand-drawn look such as June Lyon's *Gyro* wallpaper were reminiscent of metal sculptures shown at the Festival of Britain in 1951. Lucienne Day and her husband Robin were among the first 'celebrity' designers, working for a range of companies designing textiles, ceramics and furniture as well as wallpapers.

Secondly, wallpaper manufacturers started to take advantage of screen printing techniques, which were also becoming more common in textiles. Screen-printing had low set-up costs, meaning that it was possible to print relatively short runs of wallpapers cost effectively. More importantly, screen printing allowed artists to create designs that were freer and more illustrative, which suited the post-war mood of optimism.

Whether they were screen printed or not, many wallpapers of the 1950s became more abstract and geometric, or began to feature pictorial patterns. 'Boring' floral patterns were definitely out. These 'contemporary' designs may have only sold to a minority of consumers, but by 1956 this minority accounted for around 20 per cent of the market.

In the years after the Second World War, the average home became smaller and living space more compact. Previously the kitchen had been considered a private part of the house, and was unlikely to be seen by visitors. But now it became more common to have a kitchen and dining room, or kitchen and living room combined within one space. Wallpaper was frequently recommended as a way

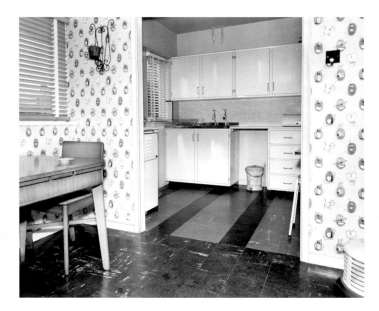

This 1950s kitchen (featuring the wallpaper in the photograph on page 37) shows how wallpaper could be used to demarcate the space between kitchen and dining area.

to demarcate the different functional areas of a room. Wallpapers that featured foodstuffs or kitchen implements were seen as particularly appropriate for kitchen and dining areas.

As in previous decades, wallpaper was often used to make a space seem like home for its new inhabitants. Young couples setting up home in the 1950s often chose to decorate with contemporary wallpaper, even if they had to make do with older, pre-war or second-hand furniture. A newly papered room represented a symbolic 'fresh start', whether for a family or for the country as a whole.

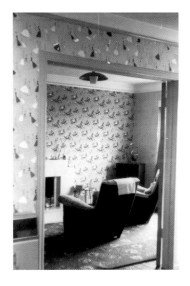

Occupants of this house in Wembley Park, London, 1958, chose a mustard yellow, blue and black pattern of dancing ladies in the hall, and black and white pagodas on a pink background over the fireplace.

Week ending November 1 1958

JOHN BULL

and

ILLUSTRATED

EVERY WEDNESDAY 4½d

HOW PETER MANUEL TALK HIMSELF TO DEATH

Curt Jurgens: The New Accent On Charm

The Greatest Raid Of Massacre Of The Little

THE NORTHERN LIGHT by A. J. CRO

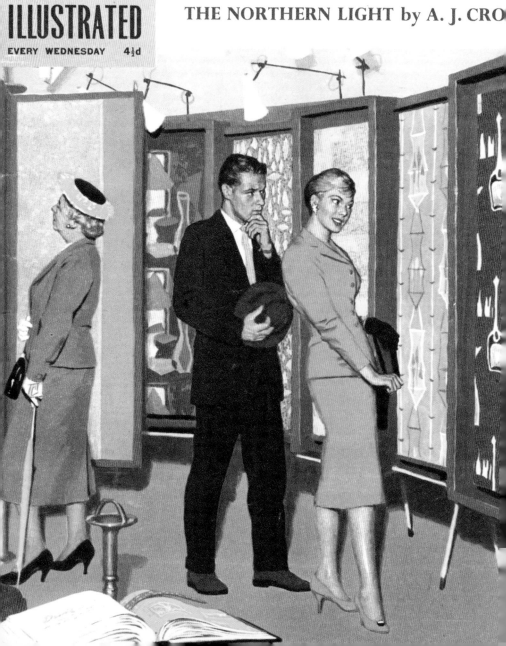

DOING IT YOURSELF

NTIL AROUND THE middle of the twentieth century, decorating was considered a skilled trade. Middle-class householders rarely tackled the decorating themselves because they generally lacked both the skills and the equipment necessary to do the job well. Decorators undertook a long apprenticeship to learn how to mix paint and distemper, to hang wallpaper, and to take care of the tools of the trade. As a result, wallpapers were marketed to decorators, rather than to consumers. Wallpaper manufacturers produced albums of wallpapers each season, and decorators would show a selection to customers, and then order the appropriate amount on their behalf.

After the Second World War, the increasing number of people owning their own home meant that more people were keen to renovate their houses. But tradesmen were in short supply, since many were employed in large projects helping to re-build Britain. Fortunately this was a time in which home decoration was starting to become easier for home-owners to tackle themselves, due to several advances in wallpaper technology. Until this point, wallpaper had been supplied with 'selvedges' that required trimming, which was a time consuming and tricky task. But in the 1950s the introduction of ready- or semi-trimmed wallpapers made wallpapering much easier for the amateur paper-hanger. In addition, easy-mix, water-soluble wallpaper paste was invented in 1953. Wallpaper companies began to market their products directly

OPPOSITE
Front cover
of *John Bull*
illustrated
magazine, 1958.
In the 1950s
wallpaper
companies began
to market their
products direct
to consumers,
rather than
selling via
decorators.

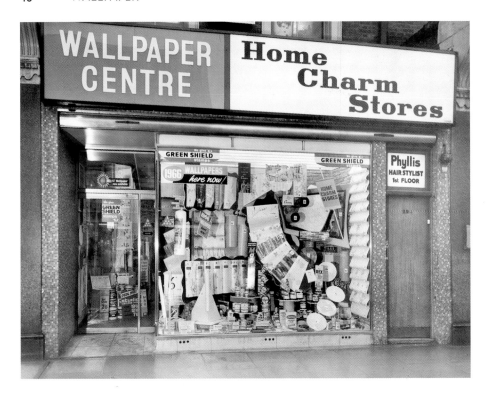

A Home Charm shop in Forest Gate, London, in 1966. Shops like this were a familiar part of Britain's high streets before the increased popularity of DIY superstores.

to consumers rather than decorators, and do-it-yourself was born. Customers started to choose their wallpapers from a retailer's stock, rather than ordering through a decorator.

John Line opened a showroom devoted exclusively to its new 'contemporary' ranges at their Tottenham Court Road headquarters, where the furniture retail trade was concentrated. Specialist showrooms encouraged consumers to browse a wide range of wallpapers and offered an opportunity to see the very latest designs.

The media soon took note of the new fashion for DIY that was developing in the 1950s. Several books were published on the subject, with 'before and after' illustrations showing the changes that could easily be made to the ordinary home. *The Practical Householder* magazine was first published in October 1955, providing instructions and general information

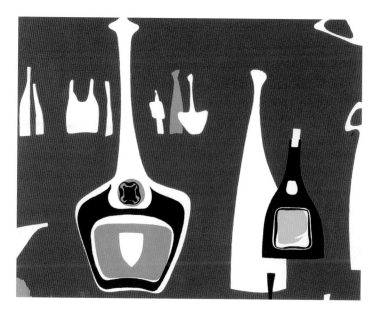

Carafe, by June Lyon, 1950s. Cheerful patterns with food and drink motifs became popular in the 1950s to decorate kitchens and dining areas, and would have worked well in modern, open plan houses.

on DIY projects. This was followed by *Do-It-Yourself*, a near identical publication whose similarity is evidence of the popularity of DIY.

Women's magazines also played a key role in marketing the increasing number of wallpapers and fabrics available to the British public throughout the 1950s. These magazines provided advice on how to decorate the home using the new 'contemporary' style. They also featured advertisements for the companies who could sell customers the product. In fact, the line between advertising and editorial was not always clear.

Magazines encouraged people to buy the new 'contemporary' designs by reproducing them in high-quality colour spreads. At the same time, columnists began to move away from the 'make do and mend' approach of wartime advice. Spending money on new products was actively encouraged, and magazines were keen to promote 'contemporary' style for every budget.

Television was another source of DIY advice, most notably in the form of Barry Bucknell, whose show *Barry Bucknell's Do-it-Yourself* attracted some seven million viewers

The Practical Householder, October 1957. The magazine encouraged the idea that jobs such as wallpapering could be tackled by the enthusiastic amateur, once equipped with the right instructions and materials.

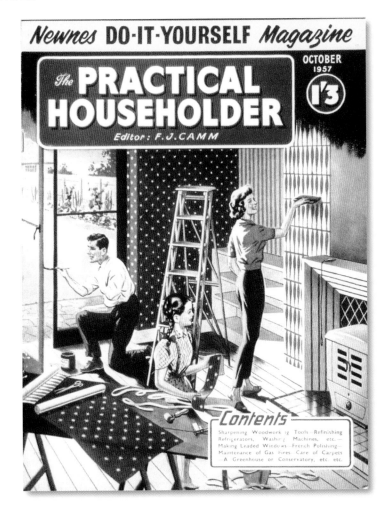

Newnes **DO-IT-YOURSELF** *Magazine*

OCTOBER 1957

The **PRACTICAL HOUSEHOLDER**

Editor: F.J.CAMM

1'3

Contents

Sharpening Woodwork'g Tools—Refinishing
Refrigerators, Washing Machines, etc.—
Making Leaded Windows—French Polishing—
Maintenance of Gas Fires—Care of Carpets
—A Greenhouse or Conservatory, etc. etc.

during the 1950s. This was followed in 1962 by *Bucknell's House*, in which he offered step-by-step instruction each week on how to renovate a dilapidated Victorian house. Bucknell demonstrated to viewers how they might rip out period features, knock down walls or update furniture, all in the name of modernisation. Projects unfolded almost in real time over a series of episodes, helping viewers to get a sense of the work involved and encouraging them to have a go themselves.

Advertisements and magazines promoted the idea that putting up wallpaper is a shortcut to domestic harmony. The happy-looking couples in the illustrations give the impression that beautifully wallpapered rooms are the *cause* of their happiness. But anyone who has ever tried to put wallpaper up knows that it can be a messy, tiring and stressful job, and that it does not always give the results you imagined. The stress

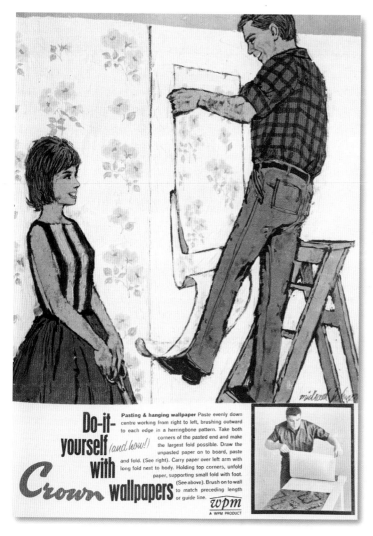

Advertisement for Crown Wallpapers, from *The Practical Householder* magazine, November 1964, including detailed instructions on how to paste and hang the paper.

comes partly from the expense, effort and skill involved, and partly from the fact that once you have bought a paper and started to put it up, it might be difficult to change your mind.

Often the effort is worth it, of course, because there is a satisfaction that comes with making a house feel like 'home'. Sometimes, however, there is a realisation that a choice of wallpaper has been a big mistake. One man from Penge re-decorated every year in the 1950s, but since money was tight he only ever bought wallpaper when it went on sale. In 1955 the only design available in sufficient quantity to paper the front room was one featuring the highwayman Dick Turpin. His daughter remembered that the family realised that they all hated the effect before he had even finished putting it up, but nobody felt able to

This Dick Turpin themed wallpaper dates from around 1955, and was used to decorate the front room of a house in Penge, South London.

Even in the twentieth century it was still relatively rare for people to take photographs of their wallpaper, except when it was a real talking point, as in this case.

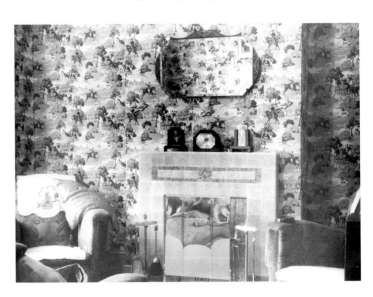

say anything. The wallpaper became such a talking point that a friend of the family, an amateur photographer, came round to take a picture of it.

This example demonstrates that there is sometimes a gap between the wallpaper that people would like and what they can actually afford. Putting up new wallpaper can be a big investment of money and time, and it is not always possible to get it right. We should also remember that often it is only the most eye-catching wallpapers that are preserved in museum collections.

In the 1950s, magazines promoted contemporary wallpapers because they photographed well in the newly available colour formats. Many of the wallpapers that we now think of as 'typical' of the 1950s were made possible by the introduction of screen printing techniques. But as in previous decades the choice of wallpaper reflected consumers' desire to look back to the past (to create a familiar and comfortable space called 'home') as well as looking forward to the future. The introduction of newer printing methods did not always mean the abandonment of older methods. The majority of wallpapers were still machine printed, and some companies continued to block print some of their ranges in order to ensure the quality of their products and to appeal to the luxury market.

Not everybody in the 1950s wanted 'contemporary' wallpaper. This pattern by Sanderson used blocks that were first used in 1905, but the use of different colours gave it a modern, luxurious feel.

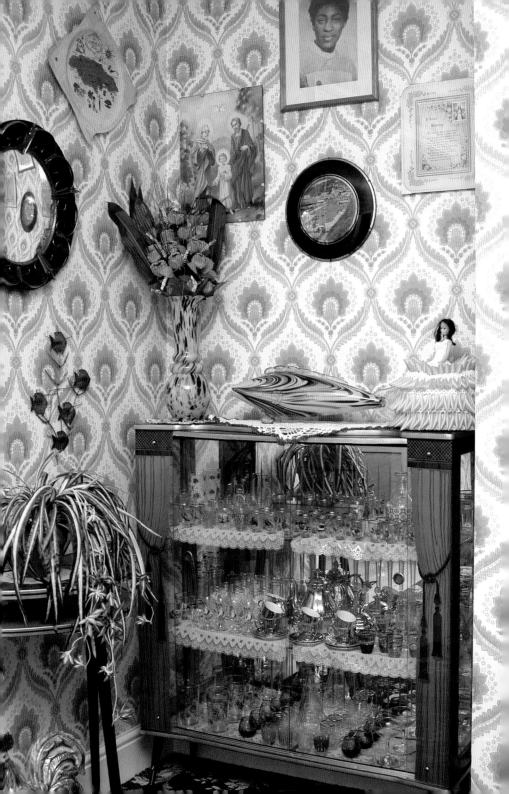

WALLPAPER IN THE LATE TWENTIETH CENTURY

WALLPAPERS INTENDED FOR use in the nursery had been available since the end of the nineteenth century, but in the late twentieth century the idea was updated to include wallpapers suitable for older children and teenagers. Wallpaper featuring pop stars represented both the commodification of teen culture, and a way in which teenagers marked their space within the house as their own. This was perhaps related to the fact that from the 1970s, as more British homes had central heating installed, it became more common for children and teenagers to spend free time in their bedrooms.

Similarly, in his book *The Front Room*, Michael McMillan has drawn attention to the way in which West Indian families used wallpaper and other furnishings in the 1960s and '70s, to create a sense of identity and establish an idea of home. The idea that the front room should be kept 'for best' had been common in Britain before the war, and this tradition continued in the West Indian community. The front room could be a space in which to express the family's Caribbean roots, while simultaneously creating a sense of identity and home in Britain. The wallpaper was frequently chosen on the basis of 'the brighter the better'. The wallpaper chosen by immigrant communities was not necessarily different from what was available to other people at the same time, but it was often paired with other furnishings in a distinctive way to create a vibrant overall effect.

OPPOSITE
A bold choice of wallpaper, combined with other furnishings in a distinctive way, helped to create a sense of home for communities arriving in Britain in the 1970s.

This Beatles wallpaper from 1964 featured the 'signatures' of each band member as well as their photographs, a sure way to appeal to teenage fans.

'Wypecleen' was one of a number of vinyl papers available in the 1960s and '70s. They were promoted as 'steam and grease resistant' and therefore suitable for kitchens, bathrooms and hallways.

Throughout its history, wallpaper manufacturers have taken advantage of new technologies to produce something new and exciting. In the last decades of the twentieth century, new materials such as vinyl coatings again promised qualities such as hygiene and durability, and were increasingly marketed as suitable for the kitchen and bathroom. Wallpapers featuring reflective metallic foils were briefly fashionable, and were often used for small spaces rather than on a large scale.

At the same time, many consumers valued traditional patterns for their homes, and in the 1970s and '80s this meant a return to traditional floral designs. Laura Ashley had established a reputation

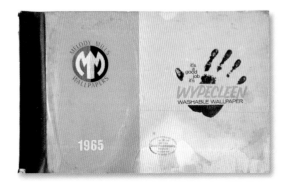

for floral dresses in the 1960s and '70s, and in the 1980s started to move into home decoration. This was the beginning of a trend towards wallpapers and furnishing fabrics in coordinated patterns. Companies such as Sandersons produced coordinating ranges of floral wallpapers and textiles; they also re-issued William Morris wallpaper designs in updated colours, providing for consumers who wanted something reassuringly familiar but perhaps in a modern colourway.

By the 1990s, the British wallpaper industry was beginning to experience a decline. This trend away from wallpaper was partly to do with the popularity of TV makeover programmes such as *Changing Rooms*, which first aired in 1996. These programmes promised quick transformation with no time for the careful task of wallpapering an entire room, although sometimes a papered 'feature wall' was included. This combined with Ikea's influential 'Chuck out your Chintz' advertising

This Sandersons advertisement epitomises the 1970s fashion for coordinated wallpapers and fabrics. These small floral patterns reflected nostalgia for rural living at a time of economic and political crisis.

Today's wallpaper designers such as Tracy Kendall produce papers to order, using screen printing and digital printing techniques. Her *Paperbacks* wallpaper is digitally printed and continues the tradition of wallpaper imitating other things, but with a modern twist.

campaign of 1996, which encouraged people to reject 'frilly' and 'fussy' furnishings in favour of a more streamlined, modern style.

Wallpaper had always helped to define and reflect the personality of a home's inhabitants. But by the end of the twentieth century, property programmes promoted the idea that it was important to present a bland and personality-free impression in order to sell a house quickly and climb the property ladder. In this context it was inevitable that wallpaper would decline in popularity. In the early 2000s, high property prices meant that an increasing number of young people were continuing to rent rather than buy their own homes. This perhaps also contributed to wallpaper's decline in popularity: landlords were reluctant to put wallpaper up because it was expensive to replace and tenants did not want to be stuck with someone else's taste in wallpaper.

Wallpaper always seems to be on the brink of going out of fashion, yet numerous newspaper and magazine articles in the first decades of the twenty-first century have announced that wallpaper is back, and better than ever. It remains popular with many people for whom bare painted walls do not feel 'warm' or 'homely' enough. Wallpaper continues to be available in a wide range of styles, and at prices to suit every pocket, from a few pounds to hundreds of pounds per roll.

As in previous centuries, wallpaper in the twenty-first century continues to reflect changes in technology. The introduction of digital printing makes a variety of new

effects possible, including photo-realist images on a huge scale intended to cover a whole wall. Digital printing makes it possible to print on demand or to customise wallpaper to the client's exact specifications. This might mean producing the customer's own image at huge scale, or producing a designer's ideas to fit a particular space.

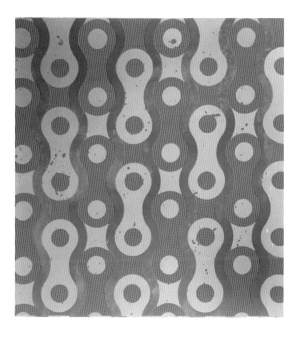

Wallpapers that promise to fulfil various high tech functions are constantly promised: in the 1960s wallpaper that would act as heater was proposed (the idea was that it would work in a similar way to night storage heaters). More recently the idea of wallpaper with inbuilt wireless technology has been discussed. However, the investment required to make any of these ideas effective is at odds with our continuing assumption that wallpaper should be cheap enough to be easily replaceable, or that its main purpose is decorative rather than functional.

This quirky design called *Bike Chain* by Brixton Print Shed is an example of a move towards wallpapers that are decorative and colourful but not based on floral motifs.

The other trend, in the increasingly digital and high tech world of the early twenty-first century, is for wallpaper that suggests the authentic, the artisan and the hand-produced. Small-scale designer-makers such as Brixton Print Shed use block printing and screen printing techniques to produce wallpapers that definitely have a handmade feel. This means that the product can be customised to the client's specifications, and consumers also like the idea that they can buy something that has been made by hand with care and skill.

Mini Moderns look to unusual subject matter for their designs, from tape cassettes to romantic comic strips. Their ranges anticipate consumers' desire for a bolder approach to pattern in the home.

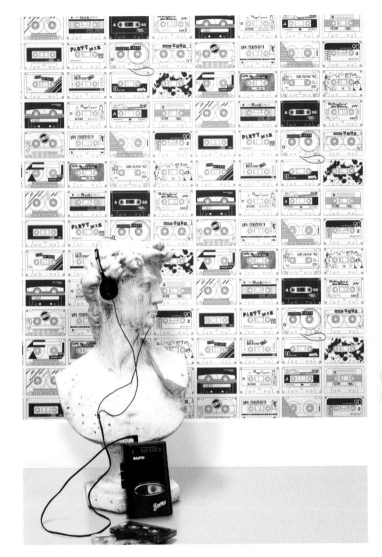

The continuing advantage of wallpaper is that it offers something for everyone, both those in search of a plain and restful backdrop, and those who favour a bolder statement. The British taste for pattern and colour has not abated, with lush florals and bold colours continuing to have a strong place in the market.

Love it or loathe it, wallpaper continues to provoke strong reactions, whether positive or negative. It remains an integral, yet frequently overlooked part of our world, since it often – quite literally – forms part of the background of our lives. Wallpaper has had an important part to play in the histories of British homes, reflecting technological, economic and social change like almost no other product.

Whether you have wallpaper in your own home or not, you probably have strong opinions about it, especially about the kinds of wallpaper you *don't* like. Wallpaper may also prompt strong memories of, or nostalgia for, homes you lived in at different points in your life. Over the centuries, wallpaper has helped to make British houses feel like 'home' and it seems that one way or another it is here to stay.

Newton Paisley designs bring the traditional floral up to date by depicting endangered species. This one takes inspiration from the Carolinas and includes carnivorous plants.

PLACES TO VISIT

HOUSES

The houses mentioned in the text that can be visited are listed below:

18 Stafford Terrace, Kensington & Chelsea, London
 W8 7BH. Telephone: 020 7602 3316. Website:
 www.rbkc.gov.uk/subsites/museums/18staffordterrace1.aspx
Christchurch Mansion, Soane Street, Ipswich, Suffolk
 IP4 2BE. Telephone: 01473 433554. Website:
 cimuseums.org.uk/visit/venues/christchurch-mansion
Jane Austen's House Museum, Winchester Road, Chawton,
 Hampshire GU34 1SD. Telephone: 01420 83262.
 Website: www.jane-austens-house-museum.org.uk
Lanhydrock, Bodmin, Cornwall PL30 5AD.
 Telephone: 01208 265950.
 Website: www.nationaltrust.org.uk/lanhydrock
Marble Hill House, Richmond Road, Twickenham, London
 TW1 2NL. Telephone: 020 8892 5115. Website:
 www.english-heritage.org.uk/visit/places/marble-hill-house/
Ormesby Hall, Ladgate Lane, Ormesby, near Middlesbrough,
 Redcar & Cleveland TS3 0SR. Telephone: 01642
 324188. Website: www.nationaltrust.org.uk/ormesby-hall
Newhailes House and Gardens, Newhailes Road,
 Musselburgh, East Lothian EH21 6RY.
 Telephone: 0131 458 0200.
 Website: www.nts.org.uk/visit/places/newhailes
Red House, Red House Lane, Bexleyheath, London,
 DA6 8JF. Telephone: 020 8304 9878.
 Website: www.nationaltrust.org.uk/red-house
Russell-Cotes Art Gallery, East Cliff Promenade,
 Bournemouth BH1 3AA. Telephone: 01202 451858.
 Website: www.russellcotes.com

Sandycombe Lodge, 40 Sandycoombe Road, St Margarets, Twickenham TW1 2LR. Telephone: 020 8892 5485. Website: www.turnershouse.org

Saltram House, Plympton, Plymouth, Devon PL7 1UH. Telephone: 01752 333500. Website: www.nationaltrust.org.uk/saltram

Standen House, West Hoathly Road, East Grinstead, West Sussex RH19 4NE. Telephone: 01342 323029. Website: www.nationaltrust.org.uk/standen-house-and-garden

Temple Newsam House, Temple Newsam Road, Selby Road, Leeds LS15 0AE. Telephone: 0113 336 7461. Website: www.leeds.gov.uk/museumsandgalleries/templenewsamhouse

Whitehall Museum, 1 Malden Road, Cheam, Surrey SM3 8QD. Telephone: 0208 770 5670. Website: www.whitehallmuseum.wordpress.com

Wightwick Manor, Wightwick Bank, Wolverhampton, West Midlands WV6 8EE. Telephone: 01902 761400. Website: www.nationaltrust.org.uk/wightwick-manor-and-gardens

William Morris Gallery, Lloyd Park, Forest Road, Walthamstow, London E17 4PP. Telephone: 020 8496 4390. Website: www.wmgallery.org.uk

MUSEUMS AND OTHER SOURCES OF INFORMATION

English Heritage, Wrest Park, Silsoe, Bedfordshire MK45 4HR. Telephone: 01525 860 000. Website: www.english-heritage.org.uk/visit/places/wrest-park

The Geffrye Museum of the Home, 136 Kingsland Road, Hoxton, London E2 8EA. Telephone: 020 7739 9893. Website: www.geffrye-museum.org.uk

Museum of Domestic Design and Architecture, Middlesex University, 9 Boulevard Drive, Beaufort Park, London NW9 5HF. Telephone: 020 8411 5244. Website: www.moda.mdx.ac.uk. Visits by appointment only.

Victoria and Albert Museum, Cromwell Road, Knightsbridge, London SW7 2RL. Telephone: 020 7942 2000.
Website: www.vam.ac.uk
Wallpaper History Society.
Website: www.wallpaperhistorysociety.org.uk
Whitworth Art Gallery, University of Manchester, Oxford Road, Manchester M15 6ER. Telephone: 0161 275 7450.
Website: www.whitworth.manchester.ac.uk

WITH ADDITIONAL THANKS TO THE FOLLOWING WALLPAPER COMPANIES MENTIONED IN THE BOOK:

Brixton Print Shed: Website: www. brixtonprintshed.org.uk
Hamilton Weston: Website: www.hamiltonweston.com
Mini Moderns: Website: www.minimoderns.com
Newton Paisley: Website: www.newtonpaisley.com
Tracy Kendall: Website: www.tracykendall.com

FURTHER READING

De Bruijn, Emile. *Chinese Wallpaper in Britain and Ireland.* Philip Wilson, 2017.

Gere, Charlotte and Hoskins, Lesley. *The House Beautiful: Oscar Wilde and the Aesthetic Interior.* Geffrye Museum & Lund Humphries, 2000.

Hawksley, Lucinda. *Bitten by Witch Fever: Wallpaper and Arsenic in the Victorian Home.* Thames & Hudson, 2016.

Hoskins, Lesley. *The Papered Wall.* Thames & Hudson, 1994.

Jackson, Lesley. *20th Century Pattern Design: Textile and Wallpaper Pioneers.* Mitchell Beazley, 2002.

MacCarthy, Fiona. *William Morris.* Faber & Faber, 1994.

McMillan, Michael. *The Front Room: Migrant Aesthetics in the Home.* Black Dog Publishing, 2009.

Rosoman, Treve. *London Wallpapers: Their Manufacture and Use, 1690–1840.* English Heritage, 1992.

Saunders, Gill. *Wallpaper in Interior Decoration.* V&A, 2002.

Schoeser, Mary. *Sanderson: The Essence of English Decoration.* Thames & Hudson, 2010.

Sugg Ryan, Deborah. *Ideal Homes, 1918–39: Domestic Design and Suburban Modernism.* Manchester University Press, 2018.

Turner, Mark. *A Popular Art: British Wallpapers, 1930–1960.* Middlesex Polytechnic, 1989.

Vickery, Amanda. 'Wallpaper and Taste,' in *Behind Closed Doors: At Home in Georgian England.* Yale University Press, 2009.

Wedd, Kit. *The Victorian House.* Aurum Press, 2002.

Wells-Cole, Anthony. *Historic Paper Hangings from Temple Newsam and other English Houses.* Leeds City Art Galleries, 1983.

INDEX

Page numbers in bold refer
to illustrations.

Allan, Cockshut & Co. **42**
Anaglypta 28–9, **29**
Arsenic 25–6, **26**, **27**
Art Deco **5**, 33
Art Nouveau **3**, 22, **24**
Beatles wallpaper **54**
Block printing 9–11, **11**, 20, 51,
 51, 57
Brixton Print Shed **57**
Bucknell, Barry 47–8
Changing Rooms 55
Chawton, Hampshire **11**
Chinese Wallpapers **6**, 8–9, **9**
Christchurch Mansion, Ipswich 8
Council of Industrial Design 38
Crane, Walter 22, **22**
Crown Wallpapers **35**, **40**, **49**
Day, Lucienne 37, **39**, 40–1, **40**
Day, Robin 40–1
Department stores 19
Digital printing **56**, 57
DIY 45–50, **46**, **48**, **49**
Dresser, Christopher **26**
East India Company 8
Eastlake, Charles 19
Festival of Britain 39–41
Flock wallpaper 7, **8**
Greenaway, Kate **28**

Groag, Jacqueline 41
Gwatkin, Arthur **24**
Hamilton Weston 11, **11**
Heywood, Higginbottom & Smith 27
Jeffrey & Co. 20, **21**, 22, 26
John Line & Sons 33, 40, **41**, 46
Jones, Owen 16–17, **16**
Kitchens 42–3, **36**, **43**, 54
Lanhydrock, Cornwall **17**
Laura Ashley 54–5
Liberty & Co. 19
Lincrusta 28–9, **29**
Lydiard House, Wiltshire **8**
Lyon, June 37, 41, **41**, **47**
Machine printing 13, **15**, 22, 33, **33**
Mahler, Marian 39
Marble Hill House, Twickenham
 6, 9
Marx, Enid 39
Mini Moderns **58**
Morris, William **18**, 19–23, **21**,
 26, 55
Newhailes House, East Lothian,
 Scotland 9
Newton Paisley **59**
Oberkampf, Christophe-Philippe 13
Ormesby Hall, Cleveland 8, **8**
Panton, Mrs Jane Ellen 19
Paradise Row, Lambeth 7, **8**
Practical Householder magazine
 46, **48**, **49**

Pugin, Augustus Welby Northmore
 17, **17**
Red House, Kent 19
Russell-Cotes Art Gallery and
 Museum, Bournemouth 29
Saltram House, Devon 9
Sambourne Linley 19
Sanderson 22–3, **23**, **32**, **51**, **55**
Sandycombe Lodge, Twickenham **11**
Sanitary wallpaper **3**, **24**, 27, **27**, **28**
Scarfe, Laurence 39
Screen printing 41, 51
Shillingford, Alan **42**
Standen, West Sussex 21
Sutherland, Graham 38–9, **38**
T. Whatley & Son, Middlesbrough
 30, 34
Teale, Thomas Pridgin 26
Temple Newsam House, Leeds 8
Tracy Kendall **56**
Tynecastle paper 28–9
Victoria & Albert Museum **9**
Whitehall House, Cheam **10**
Whiteleys department store 19
Wightwick Manor, Wolverhampton
 21
William Wallace & Co. 19, **20**
Wypecleen' wallpaper **54**
Yorke, F.R.S. 32